MR. WHISTLER'S

" TEN O'CLOCK."

London, 1888.

Delivered in London,

Feb. 20, 1885.

At Cambridge,

March 24.

At Oxford,

April 30.

LADIES AND GENTLEMEN,

It is with great hesitation and much misgiving that I appear before you, in the character of The Preacher.

If timidity be at all allied to the virtue modesty, and can find favour in your eyes, I pray you, for the sake of that virtue, accord me your utmost indulgence.

I would plead for my want of habit, did it not seem preposterous, judging from precedent, that aught save the most efficient effrontery could be ever expected in connection with my subject—for I will not conceal from you that I mean to talk about Art. Yes, Art—that has of late become, as far as much discussion and writing can make it, a sort of common topic for the tea-table.

Art is upon the Town!—to be chucked under the chin by the passing gallant—to be enticed within the gates of the householder—to be coaxed into company, as a proof of culture and refinement.

If familiarity can breed contempt, certainly Art—or what is currently taken for it—has been brought to its lowest stage of intimacy.

The people have been harassed with Art in every guise, and vexed with many methods as to its endurance. They have been told how they shall love Art, and live with it. Their homes have been invaded, their walls

covered with paper, their very dress taken to task—until, roused at last, bewildered and filled with the doubts and discomforts of senseless suggestion, they resent such intrusion, and cast forth the false prophets, who have brought the very name of the beautiful into disrepute, and derision upon themselves.

Alas! ladies and gentlemen, Art has been maligned. She has naught in common with such practices. She is a goddess of dainty thought—reticent of habit, abjuring all obtrusiveness, purposing in no way to better others.

She is, withal, selfishly occupied with her own perfection only—having no desire to teach—seeking and finding the beautiful in all conditions and in all times, as did her high priest Rembrandt, when he saw picturesque grandeur and noble dignity in the Jews' quarter of Amsterdam, and lamented not that its inhabitants were not Greeks.

As did Tintoret and Paul Veronese, among the Venetians, while not halting to change the brocaded silks for the classic draperies of Athens.

As did, at the Court of Philip, Velasquez, whose Infantas, clad in inæsthetic hoops, are, as works of Art, of the same quality as the Elgin marbles.

No reformers were these great men—no improvers of the ways of others! Their productions alone were their occupation, and, filled with the poetry of their science, they required not to alter their surroundings—for, as the laws of their Art were revealed to them, they saw, in the development of their work, that real beauty which, to them, was as much a matter of certainty and triumph as is to the astronomer the verifica-

tion of the result, foreseen with the light given to him alone. In all this, their world was completely severed from that of their fellow-creatures with whom sentiment is mistaken for poetry ; and for whom there is no perfect work that shall not be explained by the benefit conferred upon themselves.

Humanity takes the place of Art, and God's creations are excused by their usefulness. Beauty is confounded with virtue, and, before a work of Art, it is asked : "What good shall it do ? "

Hence it is that nobility of action, in this life, is hopelessly linked with the merit of the work that portrays it ; and thus the people have acquired the habit of looking, as who should say, not *at* a picture, but *through* it, at some human fact, that shall, or shall not, from a social point of view, better their mental or moral state. So we have come to hear of the painting that elevates, and of the duty of the painter—of the picture that is full of thought, and of the panel that merely decorates.

A favourite faith, dear to those who teach, is that certain periods were especially artistic, and that nations, readily named, were notably lovers of Art.

So we are told that the Greeks were, as a people, worshippers of the beautiful, and that in the fifteenth century Art was engrained in the multitude.

That the great masters lived in common understanding with their patrons—that the early Italians were artists—all—and that the demand for the lovely thing produced it.

That we, of to-day, in gross contrast to this Arcadian purity, call for the ungainly, and obtain the ugly.

That, could we but change our habits and climate— were we willing to wander in groves—could we be roasted out of broadcloth—were we to do without haste, and journey without speed, we should again *require* the spoon of Queen Anne, and pick at our peas with the fork of two prongs. And so, for the flock, little hamlets grow near Hammersmith, and the steam horse is scorned.

Useless ! quite hopeless and false is the effort !— built upon fable, and all because "a wise man has uttered a vain thing and filled his belly with the East wind."

Listen ! There never was an artistic period.

There never was an Art-loving nation.

In the beginning, man went forth each day—some to do battle, some to the chase ; others, again, to dig and to delve in the field—all that they might gain and live, or lose and die. Until there was found among them one, differing from the rest, whose pursuits attracted him not, and so he staid by the tents with the women, and traced strange devices with a burnt stick upon a gourd.

This man, who took no joy in the ways of his brethren—who cared not for conquest, and fretted in the field—this designer of quaint patterns—this deviser of the beautiful—who perceived in Nature about him curious curvings, as faces are seen in the fire—this dreamer apart, was the first artist.

And when, from the field and from afar, there came back the people, they took the gourd—and drank from out of it.

And presently there came to this man another—and, in time, others—of like nature, chosen by the Gods—and so they worked together ; and soon they fashioned, from the moistened earth, forms resembling the gourd. And with the power of creation, the heirloom of the artist, presently they went beyond the slovenly suggestion of Nature, and the first vase was born, in beautiful proportion.

And the toilers tilled, and were athirst ; and the heroes returned from fresh victories, to rejoice and to feast ; and all drank alike from the artists' goblets, fashioned cunningly, taking no note the while of the craftsman's pride, and understanding not his glory in his work ; drinking at the cup, not from choice, not from a consciousness that it was beautiful, but because, forsooth, there was none other !

And time, with more state, brought more capacity for luxury, and it became well that men should dwell in large houses, and rest upon couches, and eat at tables ; whereupon the artist, with his artificers, built palaces, and filled them with furniture, beautiful in proportion and lovely to look upon.

And the people lived in marvels of art—and ate and drank out of masterpieces—for there was nothing else to eat and to drink out of, and no bad building to live in ; no article of daily life, of luxury, or of necessity, that had not been handed down from the design of the master, and made by his workmen.

And the people questioned not, *and had nothing to say in the matter.*

So Greece was in its splendour, and Art reigned supreme—by force of fact, not by election—and there was no meddling from the outsider. The mighty warrior would no more have ventured to offer a design for the temple of Pallas Athene than would the sacred poet have proffered a plan for constructing the catapult.

And the Amateur was unknown—and the Dilettante undreamed of !

And history wrote on, and conquest accompanied civilisation, and Art spread, or rather its products were carried by the victors among the vanquished from one country to another. And the customs of cultivation covered the face of the earth, so that all peoples continued to use what *the artist alone produced.*

And centuries passed in this using, and the world was flooded with all that was beautiful, until there

arose a new class, who discovered the cheap, and fore-saw fortune in the facture of the sham.

Then sprang into existence the tawdry, the common, the gew-gaw.

The taste of the tradesman supplanted the science of the artist, and what was born of the million went back to them, and charmed them, for it was after their own heart ; and the great and the small, the statesman and the slave, took to themselves the abomination that was tendered, and preferred it—and have lived with it ever since !

And the artist's occupation was gone, and the manu-facturer and the huckster took his place.

And now the heroes filled from the jugs and drank from the bowls—with understanding—noting the glare of their new bravery, and taking pride in its worth.

And the people—this time—had much to say in the matter—and all were satisfied. And Birmingham and Manchester arose in their might—and Art was relegated to the curiosity shop.

Nature contains the elements, in colour and form, of all pictures, as the keyboard contains the notes of all music.

But the artist is born to pick, and choose, and group with science, these elements, that the result may be beautiful—as the musician gathers his notes, and forms his chords, until he bring forth from chaos glorious harmony.

To say to the painter, that Nature is to be taken as she is, is to say to the player, that he may sit on the piano.

That Nature is always right, is an assertion, artistically, as untrue, as it is one whose truth is universally taken for granted. Nature is very rarely right, to such an extent even, that it might almost be said that Nature is usually wrong : that is to say, the condition of things that shall bring about the perfection of harmony worthy a picture is rare, and not common at all.

This would seem, to even the most intelligent, a doctrine almost blasphemous. So incorporated with our education has the supposed aphorism become, that its belief is held to be part of our moral being, and the words themselves have, in our ear, the ring of religion. Still, seldom does Nature succeed in producing a picture.

The sun blares, the wind blows from the east, the sky is bereft of cloud, and without, all is of

iron. The windows of the Crystal Palace are seen from all points of London. The holiday maker rejoices in the glorious day, and the painter turns aside to shut his eyes.

How little this is understood, and how dutifully the casual in Nature is accepted as sublime, may be gathered from the unlimited admiration daily produced by a very foolish sunset.

The dignity of the snow-capped mountain is lost in distinctness, but the joy of the tourist is to recognise the traveller on the top. The desire to see, for the sake of seeing, is, with the mass, alone the one to be gratified, hence the delight in detail.

And when the evening mist clothes the riverside with poetry, as with a veil, and the poor buildings lose themselves in the dim sky, and the tall chimneys become campanili, and the warehouses are palaces in the night, and the whole city hangs in the heavens, and fairy-land is before us—then the wayfarer hastens home ; the working man and the cultured one, the wise man and the one of pleasure, cease to understand, as they have ceased to see, and Nature, who, for once, has sung in tune, sings her exquisite song to the artist alone, her son and her master—her son in that he loves her, her master in that he knows her.

To him her secrets are unfolded, to him her lessons have become gradually clear. He looks at her flower, not with the enlarging lens, that he may gather facts for the botanist, but with the light of the one who sees in her choice selection of brilliant tones and delicate tints, suggestions of future harmonies.

He does not confine himself to purposeless copying, without thought, each blade of grass, as commended by the inconsequent, but, in the long curve of the narrow leaf, corrected by the straight tall stem, he learns how grace is wedded to dignity, how strength enhances sweetness, that elegance shall be the result.

In the citron wing of the pale butterfly, with its dainty spots of orange, he sees before him the stately halls of fair gold, with their slender saffron pillars, and is taught how the delicate drawing high upon the walls shall be traced in tender tones of orpiment, and repeated by the base in notes of graver hue.

In all that is dainty and lovable he finds hints for his own combinations, and *thus* is Nature ever his resource and always at his service, and to him is naught refused.

Through his brain, as through the last alembic, is distilled the refined essence of that thought which began with the Gods, and which they left him to carry out.

Set apart by them to complete their works, he produces that wondrous thing called the masterpiece, which surpasses in perfection all that they have contrived in what is called Nature ; and the Gods stand by and marvel, and perceive how far away more beautiful is the Venus of Melos than was their own Eve.

For some time past, the unattached writer has become the middleman in this matter of Art, and his influence, while it has widened the gulf between the people and the painter, has brought about the most complete misunderstanding as to the aim of the picture.

For him a picture is more or less a hieroglyph or symbol of story. Apart from a few technical terms, for the display of which he finds an occasion, the work is considered absolutely from a literary point of view ; indeed, from what other can he consider it ? And in his essays he deals with it as with a novel—a history—or an anecdote. He fails entirely and most naturally to see its excellences, or demerits—artistic—and so degrades Art, by supposing it a method of bringing about a literary climax.

It thus, in his hands, becomes merely a means of perpetrating something further, and its mission is made a secondary one, even as a means is second to an end.

The thoughts emphasised, noble or other, are inevitably attached to the incident, and become more or less noble, according to the eloquence or mental quality of the writer, who looks, the while, with disdain, upon what he holds as " mere execution "—a matter belonging, he believes, to the training of the schools, and the reward of assiduity. So that, as he goes on with his translation from canvas to paper, the work becomes

his own. He finds poetry where he would feel it were he himself transcribing the event, invention in the intricacy of the *mise en scène*, and noble philosophy in some detail of philanthropy, courage, modesty, or virtue, suggested to him by the occurrence.

All this might be brought before him, and his imagination be appealed to, by a very poor picture—indeed, I might safely say that it generally is.

Meanwhile, the *painter's* poetry is quite lost to him— the amazing invention, that shall have put form and colour into such perfect harmony, that exquisiteness is the result, he is without understanding—the nobility of thought, that shall have given the artist's dignity to the whole, says to him absolutely nothing.

So that his praises are published, for virtues we would blush to possess—while the great qualities, that distinguish the one work from the thousand, that make of the masterpiece the thing of beauty that it is—have never been seen at all.

That this is so, we can make sure of, by looking back at old reviews upon past exhibitions, and reading the flatteries lavished upon men who have since been forgotten altogether—but, upon whose works, the language has been exhausted, in rhapsodies—that left nothing for the National Gallery.

A curious matter, in its effect upon the judgment of these gentlemen, is the accepted vocabulary, of poetic symbolism, that helps them, by habit, in dealing with Nature : a mountain, to them, is synonymous with

height—a lake, with depth—the ocean, with vastness—the sun, with glory.

So that a picture with a mountain, a lake, and an ocean—however poor in paint—is inevitably "lofty," "vast," "infinite," and "glorious"—on paper.

There are those also, sombre of mien, and wise with the wisdom of books, who frequent museums and burrow in crypts ; collecting—comparing—compiling—classifying—contradicting.

Experts these—for whom a date is an accomplishment—a hall mark, success !

Careful in scrutiny are they, and conscientious of judgment—establishing, with due weight, unimportant reputations—discovering the picture, by the stain on the back—testing the torso, by the leg that is missing—filling folios with doubts on the way of that limb—disputatious and dictatorial, concerning the birthplace of inferior persons—speculating, in much writing, upon the great worth of bad work.

True clerks of the collection, they mix memoranda with ambition, and, reducing Art to statistics, they "file" the fifteenth century, and "pigeon-hole" the antique !

Then the Preacher—"appointed" !

He stands in high places—harangues and holds forth.

Sage of the Universities—learned in many matters, and of much experience in all, save his subject.

Exhorting—denouncing—directing.

Filled with wrath and earnestness.

Bringing powers of persuasion, and polish of language, to prove——nothing.

Torn with much teaching—having naught to impart.

Impressive—important—shallow.

Defiant—distressed—desperate.

Crying out, and cutting himself—while the Gods hear not.

Gentle priest of the Philistine withal, again he ambles pleasantly from all point, and through many volumes, escaping scientific assertion—"babbles of green fields."

So Art has become foolishly confounded with education—that all should be equally qualified.

Whereas, while polish, refinement, culture, and breeding, are in no way arguments for artistic result, it is also no reproach to the most finished scholar or greatest gentleman in the land that he be absolutely without eye for painting or ear for music—that in his heart he prefer the popular print to the scratch of Rembrandt's needle, or the songs of the hall to Beethoven's "C minor Symphony."

Let him have but the wit to say so, and not feel the admission a proof of inferiority.

Art happens—no hovel is safe from it, no Prince may depend upon it, the vastest intelligence cannot bring it about, and puny efforts to make it universal end in quaint comedy, and coarse farce.

This is as it should be—and all attempts to make it otherwise, are due to the eloquence of the ignorant, the zeal of the conceited.

The boundary line is clear. Far from me to propose to bridge it over—that the pestered people be pushed across. No! I would save them from further fatigue. I would come to their relief, and would lift from their shoulders this incubus of Art.

Why, after centuries of freedom from it, and indifference to it, should it now be thrust upon them by the blind—until, wearied and puzzled, they know no longer how they shall eat or drink—how they shall sit or stand—or wherewithal they shall clothe themselves —without afflicting Art?

But, lo ! there is much talk without !

Triumphantly they cry, "Beware ! This matter does indeed concern us. We also have our part in all true Art !—for, remember the 'one touch of Nature' that 'makes the whole world kin.'"

True, indeed. But let not the unwary jauntily suppose that Shakespeare herewith hands him his passport to Paradise, and thus permits him speech among the chosen. Rather, learn that, in this very sentence, he is condemned to remain without—to continue with the common.

This one chord that vibrates with all—this "one touch of Nature" that calls aloud to the response of each—that explains the popularity of the "Bull" of Paul Potter — that excuses the price of Murillo's "Conception" — this one unspoken sympathy that pervades humanity, is—Vulgarity !

Vulgarity—under whose fascinating influence "the many" have elbowed "the few," and the gentle circle of Art swarms with the intoxicated mob of mediocrity, whose leaders prate and counsel, and call aloud, where the gods once spoke in whisper !

And now from their midst the Dilettante stalks abroad. The amateur is loosed. The voice of the æsthete is heard in the land, and catastrophe is upon us.

The meddler beckons the vengeance of the gods, and ridicule threatens the fair daughters of the land.

And there are curious converts to a weird *culte*, in which all instinct for attractiveness—all freshness and sparkle—all woman's winsomeness—is to give way to a strange vocation for the unlovely—and this desecration in the name of the Graces!

Shall this gaunt, ill-at-ease, distressed, abashed mixture of *mauvaise honte* and desperate assertion, call itself artistic, and claim cousinship with the artist—who delights in the dainty—the sharp, bright gaiety of beauty?

No!—a thousand times no! Here are no connections of ours.

We will have nothing to do with them.

Forced to seriousness, that emptiness may be hidden, they dare not smile—

While the artist, in fulness of heart and head, is glad, and laughs aloud, and is happy in his strength, and is merry at the pompous pretension—the solemn silliness that surrounds him.

For Art and Joy go together, with bold openness, and high head, and ready hand—fearing naught, and dreading no exposure.

Know, then, all beautiful women, that we are with you. Pay no heed, we pray you, to this outcry of the unbecoming—this last plea for the plain.

It concerns you not.

Your own instinct is near the truth—your own wit far surer guide than the untaught ventures of thick-heeled Apollos.

What ! will you up and follow the first piper that leads you down Petticoat Lane, there, on a Sabbath, to gather, for the week, from the dull rags of ages, wherewith to bedeck yourselves? that, beneath your travestied awkwardness, we have trouble to find your own dainty selves? Oh, fie ! Is the world, then, exhausted ? and must we go back because the thumb of the mountebank jerks the other way ?

Costume is not dress.

And the wearers of wardrobes may not be doctors of taste !

For by what authority shall these be pretty masters ? Look well, and nothing have they invented—nothing put together for comeliness' sake.

Haphazard from their shoulders hang the garments of the hawker—combining in their person the motley of many manners with the medley of the mummers' closet.

Set up as a warning, and a finger-post of danger, they point to the disastrous effect of Art upon the middle classes.

Why this lifting of the brow in deprecation of the present—this pathos in reference to the past?

If Art be rare to-day, it was seldom heretofore.

It is false, this teaching of decay.

The master stands in no relation to the moment at which he occurs—a monument of isolation—hinting at sadness—having no part in the progress of his fellow men.

He is also no more the product of civilisation than is the scientific truth asserted, dependent upon the wisdom of a period. The assertion itself requires the *man* to make it. The truth was from the beginning.

So Art is limited to the infinite, and beginning there cannot progress.

A silent indication of its wayward independence from all extraneous advance, is in the absolutely unchanged condition and form of implement since the beginning of things.

The painter has but the same pencil—the sculptor the chisel of centuries.

Colours are not more since the heavy hangings of night were first drawn aside, and the loveliness of light revealed.

Neither chemist nor engineer can offer new elements of the masterpiece.

False again, the fabled link between the grandeur of Art and the glories and virtues of the State, for Art feeds not upon nations, and peoples may be wiped from the face of the earth, but Art *is*.

It is indeed high time that we cast aside the weary weight of responsibility and copartnership, and know that, in no way, do our virtues minister to its worth, in no way do our vices impede its triumph !

How irksome ! how hopeless ! how superhuman the self-imposed task of the nation ! How sublimely vain the belief that it shall live nobly or art perish !

Let us reassure ourselves, at our own option is our virtue. Art we in no way affect.

A whimsical goddess, and a capricious, her strong sense of joy tolerates no dulness, and, live we never so spotlessly, still may she turn her back upon us.

As, from time immemorial, has she done upon the Swiss in their mountains.

What more worthy people! Whose every Alpine gap yawns with tradition, and is stocked with noble story ; yet, the perverse and scornful one will none of it, and the sons of patriots are left with the clock that turns the mill, and the sudden cuckoo, with difficulty restrained in its box !

For this was Tell a hero ! For this did Gessler die !

Art, the cruel jade, cares not, and hardens her heart, and hies her off to the East, to find, among the opium-eaters of Nankin, a favourite with whom she lingers fondly—caressing his blue porcelain, and painting his coy maidens, and marking his plates with her six marks of choice—indifferent, in her companionship with him, to all save the virtue of his refinement !

He it is who calls her—he who holds her !

And again to the West, that her next lover may bring together the Gallery at Madrid, and show to the world how the Master towers above all ; and in their intimacy they revel, he and she, in this knowledge ; and he knows the happiness untasted by other mortal.

She is proud of her comrade, and promises that, in after years, others shall pass that way, and understand.

So in all time does this superb one cast about for the man worthy her love—and Art seeks the Artist alone.

Where he is, there she appears, and remains with him —loving and fruitful—turning never aside in moments of hope deferred—of insult—and of ribald misunderstanding ; and when he dies she sadly takes her flight, though loitering yet in the land, from fond association, but refusing to be consoled.*

With the man, then, and not with the multitude, are her intimacies ; and in the book of her life the names

* And so have we the ephemeral influence of the Master's memory—the afterglow, in which are warmed, for a while, the worker and disciple.

inscribed are few—scant, indeed, the list of those who have helped to write her story of love and beauty.

From the sunny morning, when, with her glorious Greek relenting, she yielded up the secret of repeated line, as, with his hand in hers, together they marked, in marble, the measured rhyme of lovely limb and draperies flowing in unison, to the day when she dipped the Spaniard's brush in light and air, and made his people live within their frames, and *stand upon their legs*, that all nobility and sweetness, and tenderness, and magnificence should be theirs by right, ages had gone by, and few had been her choice.

Countless, indeed, the horde of pretenders ! But she knew them not.

A teeming, seething, busy mass, whose virtue was industry, and whose industry was vice !

Their names go to fill the catalogue of the collection at home, of the gallery abroad, for the delectation of the bagman and the critic.

Therefore have we cause to be merry !—and to cast away all care—resolved that all is well—as it ever was —and that it is not meet that we should be cried at, and urged to take measures !

Enough have we endured of dulness ! Surely are we weary of weeping, and our tears have been cozened from us falsely for they have called out woe ! when there was no grief—and, alas ! where all is fair !

We have then but to wait—until, with the mark of the gods upon him—there come among us again the chosen—who shall continue what has gone before. Satisfied that, even were he never to appear, the story of the beautiful is already complete—hewn in the marbles of the Parthenon—and broidered, with the birds, upon the fan of Hokusai — at the foot of Fusi-yama.

WHISTLER'S
'TEN O'CLOCK' LECTURE

James McNeill Whistler (1834-1903) was a leading figure of the Æsthetic Movement and exponent of 'L'art pour l'art' (Art for Art's Sake) – the proposal that the intrinsic value of art is divorced from any didactic, moral or useful function. Whistler's letters and pamphlets on art matters established him in an increasingly public role, and the 'Ten O'Clock' Lecture of 1885, published in Britain, Boston and New York in 1888 and translated by the Symbolist poet Stéphane Mallarmé for publication in France in the same year, had a significant and lasting influence in Europe and America.[1]

A prolific painter and printmaker, Whistler was also known as a dandy and wit, a charming but also controversial figure. The titles of his portraits emphasized the importance of colour over subject: the portrait of his mother, now in the Musée d'Orsay, for instance, was an 'Arrangement in Grey and Black'. His 'Nocturnes' encouraged a new vision of the city, transformed by darkness and mist. When in 1877 the art critic John Ruskin accused Whistler of 'throwing a pot of paint in the public's face', Whistler sued Ruskin for libel and won – and went bankrupt as a

result. His reputation and fortunes were re-established with a series of exhibitions – etchings of Venice, small paintings and pastels- shown in harmonious surroundings in Bond Street galleries, marketed vigorously by the artist and his dealers.

Whistler's self-promotion and assertion of his ideas on art culminated in a public lecture. Allan S. Cole (son of Sir Henry Cole of the South Kensington) recorded the development of the lecture. The artist had been invited to lecture in Dublin, but this fell through, and was replaced with the idea of a London venue: Cole noted in his diary that on 7 December 1884, Whistler came to supper, and 'read us his lecture on Art, which is capital, full of vivid descriptiveness.' Then on 19 December, Whistler was 'completing his lecture, which he read to us. It is quite admirable from its poetry – simplicity – vivacity and interest.' [2]

As well as Cole, friends, family, and the young artists who surrounded Whistler – including Mortimer Menpes and Walter Sickert – listened and jotted down notes as the lecture evolved. Textual changes show that he developed individual ideas and only later constructed a narrative. His language owed much to the Bible and a strict Christian upbringing, as well as a good academic education on both sides of the Atlantic (St Petersburg, London, and West Point included). He attacked Ruskin – using both biblical and Shakespearian (from Henry V) quotations – 'Gentle priest of the Philistine … he babbles of green fields'. Whistler

press and art dealers – were generous in praise. 'Bravo bravissimo bravississississississississimo!' said Emilie Venturi.[16] 'I knew it would be a success!' wrote the sculptor J. E. Boehm, 'but it surpassed my keenest expectation'.[17] Cole wrote 'Your success amazed every one – I know of some who came to smile and be amused for friendship's sake as they said, but who left in a state of meditation & dumbness … I was very glad to tell Madame [Whistler's mistress, Maud Franklin] … how completely satisfactory I felt the whole thing had been.'[18] The result was flattering for the artist, and economically successful, for patrons and art dealers appreciated the publicity it engendered. Ernest Brown of the Fine Art Society wrote: 'It was a triumphant success and I hear on all sides that people were quite surprised at the poetry and eloquence. You held them from the first word to the last. It was a great intellectual treat to me.'[19]

Among the many reviewers, Oscar Wilde commented astutely on the lecture, his disagreements with Whistler leavened by humour and praise: [20]

> *Last night, at Prince's Hall, Mr Whistler made his first public appearance as a lecturer on art, and spoke for more than an hour with really marvellous eloquence on the absolute uselessness of all lectures of the kind … he stood there… like a brilliant surgeon lecturing to a class composed of subjects destined ultimately for dissection, and solemnly assuring them how valuable to science their mal-*

adies were, ... the audience ... seemed extremely gratified at being rid of the dreadful responsibility of admiring anything, and nothing could have exceeded their enthusiasm when they were told by Mr. Whistler that no matter how vulgar their dresses were, ... still it was possible that a great painter... could, by contemplating them in the twilight and half closing his eyes, see them under really picturesque conditions, and produce a picture which they were not to attempt to understand, much less dare to enjoy.

Although Wilde begged to differ on several points, he concluded, 'For that he is indeed one of the very greatest masters of painting is my opinion. And I may add that in this opinion Mr. Whistler himself entirely concurs'.[21]

Margaret F. MacDonald
Professor Emeritus, School of Culture and Creative Arts,
University of Glasgow

'

NOTES

1. Mr Whistler's "Ten O'Clock", *Chatto & Windus, London 1885 (limited edition);* Mr Whistler's "Ten O'Clock", *Chatto & Windus, London,1888;* "Ten O'Clock", *Houghton Mifflin & Co., Boston & New York, 1888; republished in J. McN. Whistler,* The Gentle Art of Making Enemies, *London and New York, 1890, and 2nd edition, 1892.* Le "Ten O'Clock" de M. Whistler, *translated by Mallarmé, London & Paris, 1888.*

2. The Correspondence of James McNeill Whistler, 1855-1903, *edited by Margaret F. MacDonald, Patricia de Montfort and Nigel Thorp; including* The Correspondence of Anna McNeill Whistler, 1855-1880, *edited by Georgia Toutziari. On-line edition, University of Glasgow http://www.whistler. arts.gla.ac.uk/correspondence (hereafter referred to as GUW): A.S.Cole, copy of diary, GUW 06761.*

3. GUW 06761; see Benjamin Franklin's Thirteen Virtues of Life.

4. A.S. Cole, copy in GUL, GUW 03432; see E.R. and J. Pennell, The Life of J.McN. Whistler, *1908, II, chap. XXVIII.*

5. Lenoir to A. Forbes, 8 January 1885, GUW 00924.

6. [1/20 February 1885], GUW 09032.

7. See P. de Montfort, 'Whistler's Ten O'Clock Lecture', Quarterly Ephemera, *2005, I (3), pp. 81-90.*

8. *[12/23 January 1885], GUW 07403*

9. *[17 January 1885], GUW 09548.*

10. *GUW 08147.*

11. *'Mr Whistler's "Ten O'Clock."'*, The Times, *London, 21 February 1885, p. 7.*

12. *Oscar Wilde, 'Mr Whistler's Ten O'Clock,'* Pall Mall Gazette, *vol. 41, no. 6224, 21 February 1885, pp. 1-2.*

13. *Letter, 30 Sept.-22 Nov. 1868, GUW 11983.*

14. *[18 January 1873], GUW 09182.*

15. *21 February 1885, in Whistler's press-cutting book, Glasgow University Library (GUL), Special Collections, Whistler PC8./24.*

16. *[21 Feb. 1885], GUW 05958.*

17. *20 February 1885, GUW 00328.*

18. *21 Feb. 1885, GUW 00642.*

19. *20/28 February 1885], GUW 01177.*

20. *Oscar Wilde, op. cit., reproduced (with editorial changes) in*
J. McN. Whistler, The Gentle Art of Making Enemies, *London and New York, 1890, p. 161; see GUW 11405.*

21. *Pall Mall Gazette, 21 February 1885.*

MORE FROM PALLAS ATHENE

DECADENCE

Passionate Attitudes: The English Decadents of the 1890s
Matthew Sturgis
ISBN 978 1 84368 073 4 £16.99

AUBREY BEARDSLEY

Aubrey Beardsley: A Biography
Matthew Sturgis
ISBN 978 1 84368 190 8 £19.99

Aubrey Beardsley
Robert Ross
ISBN 978 1 84368 072 7 £9.99

Bons Mots & Grotesques
Aubrey Beardsley
ISBN 978 1 84368 191 5 £12.99

RUSKIN

Worlds of John Ruskin
Kevin Jackson
ISBN 978 1 84368 148 9 £17.99

Ruskinland
Andrew Hill
ISBN 987 1 84368 175 5 £19.99

Publisher's Note
'Mr. Whistler's "Ten O'Clock"' was first published
in a private edition of 25 copies in 1885,
at the time of the original lectures.
The first public edition was issued in 1888,
by Whistler working with Chatto and Windus.
Whistler's design ethos is clear throughout,
not least in the brown paper wrapper used as a binding.
It was printed by Spottiswoode and Co.
This is the edition that has been reproduced here.

🐞 🐞 🐞

This edition first published 2011 by
Pallas Athene,
Studio 11A, Archway Studios,
25-27 Bickerton Road, London N19 5JT
www.pallasathene.co.uk

Reprinted 2020

Series editor: Alexander Fyjis-Walker
Special thanks to Stephen Calloway
and to Margaret MacDonald

ISBN *978 1 84368 075 8*

Printed in England

drafted and rewrote passages in the long dark winter evenings. A wholesale dismissal of boring artists, 'They overrun the town! a teeming seething boiling mass – whose virtue is Industry – and whose Industry is Vice!' was refined to read: 'A teeming, seething, busy mass, whose virtue was industry, and whose industry was vice!' [3]

By 14 February 1885, according to Cole, Whistler was rewriting the lecture until 1 o'clock, and on the day, 20 February, 'Jimmy's "Ten O'Clock." He gave it excellently by heart.' [4] *The title was based on the time of the lecture, 10 o'clock in the evening, which gave London Society time to dine in comfort before attending the event.*

The impresario Richard D'Oyly Carte and his business manager Helen Lenoir, organised the venue and tickets – suggesting that D'Oyly Carte would take the hall and risk, dividing the profits with the lecturer (this was an arrangement that had worked well for the American tours of Matthew Arnold and Oscar Wilde). The rental for Prince's Hall was £12.12.0 including gas lighting; the stalls seated 500; the press received free tickets but otherwise seats cost ten shillings and six pence. [5] *Despite Cole's hospitality and assistance, Whistler still insisted that he pay to attend the lecture: 'even Walter Sickert is made to fork out his 10/6 – and also my brother the Doctor'.* [6]

Notices were sent to the press and critics targeted by Whistler and Lenoir. [7] *Whistler went in for effective self-promotion, and was an active salesman. For instance, he*

wrote to Theodore Watts-Dunton, critic and poet: 'Miss Lenoir has made a note of a special seat to be set aside for you in the front row, so that you may lose none of the golden words.'[8] The critic evidently felt he should have received a ticket for free, but Whistler was persuasive: 'you ought to be quite near – so that you may hear – even if I whisper! – Seriously I am to give nothing away – the D'Oyly Cartes run the show! so there! – and the most beautiful... as well as the most brilliant and distinguished in the land... put down their gold'.[9] An American sculptor, Waldo Storey was urged to come with his wife: 'It will be Amazing!'[10]

The 'Ten O'Clock' Lecture was delivered in the Princes Hall, London, on 20 February 1885, and on several occasions later in the year. The Times devoted a long column to the lecture, commenting that 'the fashionable audience ... had assembled in the expectation that the eccentric genius of the artist would find them amusement for an hour. Their faith was not misplaced.'[11] Whistler appeared on stage, dapper in evening dress, slightly nervous, but gave an accomplished performance. The Daily Telegraph described him as an 'amiable eccentric... a jaunty, unabashed, composed, and self-satisfied gentleman, armed with an opera hat and an eyeglass.' Oscar Wilde called him 'a miniature Mephistopheles mocking the majority.'[12]

Whistler promoted ideas on style and subject matter based on his admiration for the old masters: 'her high priest Rembrandt ... saw picturesque grandeur and noble dignity

in the Jews' quarter of Amsterdam, and lamented not that its inhabitants were not Greeks', he said, and praised Tintoretto, Veronese, Velazquez, the Elgin marbles, and Japanese print makers. He dispraised the Royal Academy, æsthetic costume ('costume is not dress', he announced), Ruskin, art critics, and even art historians.

Whistler was not entirely original in his ideas; the lecture was a composite drawn from many sources. Théophile Gautier and Baudelaire, the poet Algernon Swinburne and critic Walter Pater would have found familiar ideas in Whistler's statements on art and the role of the artist. Whistler had formulated his ideas over many years: for instance, he discussed colour harmony with Henri Fantin-Latour, a friend since student days in Paris: 'les couleurs doivent être pour ainsi dire brodées là dessus'; – colours should be embroidered on the canvas, 'forming in this way an harmonious pattern – Look how the Japanese understand this!' ¹³ Nearly twenty years later, the 'Ten O'Clock' ended with the words: 'the story of the beautiful is already complete – hewn in the marbles of the Parthenon – and broidered, with the birds, upon the fan of Hokusai – at the foot of Fusiyama'.

Likewise, in 1873 Whistler wrote to an American friend, the art dealer G. A. Lucas, that his pictures were 'intended to indicate slightly to "those whom it may concern" something of my theory in art – The science of color and "picture pattern" as I have worked it out for myself during these

years'.[14] These ideas were developed in the 1885 lecture: 'Nature contains the elements, in colour and form of all pictures, as the keyboard contains the notes of all music. But the artist is born to pick, and choose, and group with science, these elements, that the result may be beautiful – as the musician gathers his notes, and forms his chords, until he bring forth from chaos glorious harmony.'

Whistler's own experience contributed to vivid passages in the lecture: his trademark 'Nocturnes' combined with his experiences in Venice, for instance, to inspire the famous passage:

> And when the evening mist clothes the riverside with poetry, as with a veil, and the poor buildings lose themselves in the dim sky, and the tall chimneys become campanili, and the warehouses are palaces in the night, and the whole city hangs in the heavens, and fairyland is before us – then the wayfarer hastens home; the working man and the cultured one, … cease to understand, as they have ceased to see, and Nature, who, for once, has sung in tune, sings her exquisite song to the artist alone...'

Oscar Wilde commented particularly that in this 'passage of singular beauty, not unlike one that accurs in Corot's letters, [Whistler] spoke of the artistic value of dim dawns and dusks, when the mean facts of life are lost in exquisite and evanescent effects'.[15]

Those who attended – artists, admirers, family, friends,